heaven in

National
Gallery

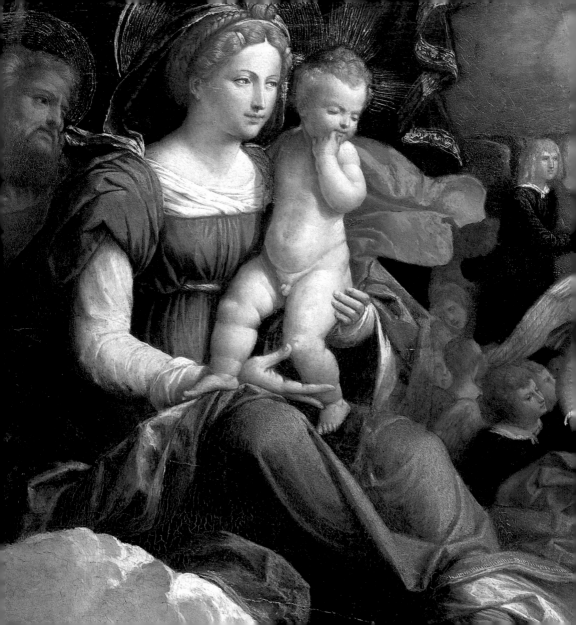

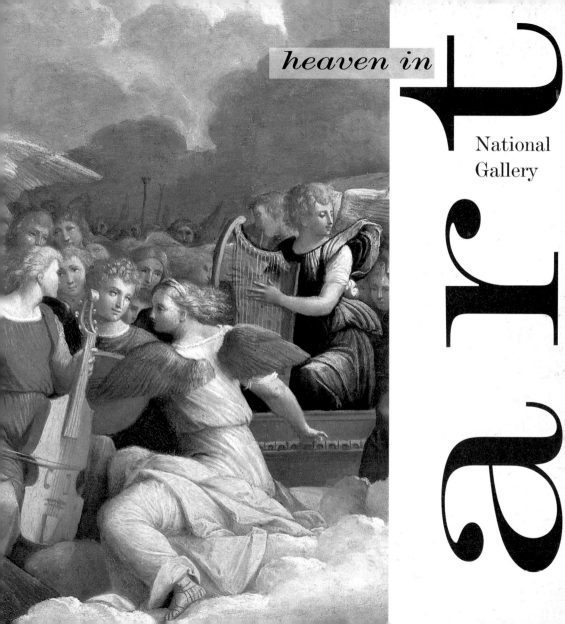

heaven in

art

National
Gallery

Sandro Botticelli: detail of *Mystic Nativity*

First published in the United States in 1998 by
Watson-Guptill Publications, Inc.
a division of BPI Communications, Inc.
1515 Broadway
New York, NY 10036

Series Editor: Ljiljana Ortolja-Baird
Designer: Bet Ayer

Library of Congress Catalog Card Number: 98-85857

ISBN: 0-8230-0334-5

First published in the United Kingdom in 1998 by
MQ Publications Ltd.
254–258 Goswell Road
London EC1V 7EB

Printed and bound in Italy

1 2 3 4 5 6 7 8 / 05 04 03 02 01 00 99 98

Title page: Garofalo, detail of *Saint Augustine and the Holy Family
and Saint Catherine of Alexandria ('The Vision of Saint Augustine')*

Fra Filippo Lippi: detail of *Seven Saints*

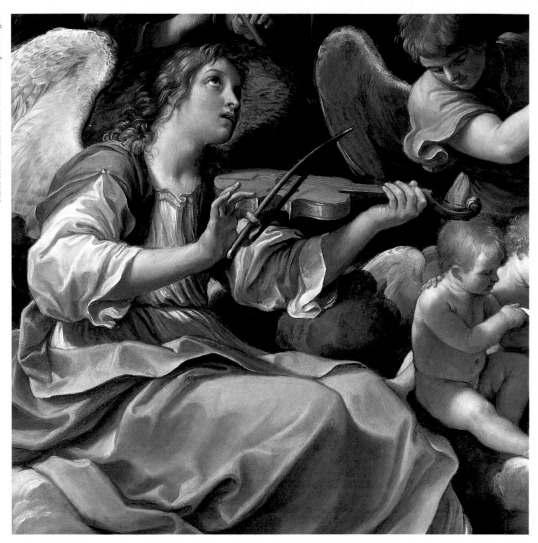

6

Introduction

'As painting, so poetry'. Like all siblings, the Sister Arts are rivals and allies. In the mirrors they hold up to nature we see ourselves reflected from varying angles and by different lights.

The National Gallery in London is home to many of the world's finest European paintings. For hundreds of years, the main task of such paintings was to assist Christian devotion: to make the invisible tenets of faith visible to plain sight. Above all, the artists strove to surpass the evocative power of the words spoken and sung by prophets, mystics and poets, by depicting, in precious materials and with exquisite craft, the resplendence of Heaven, the ineffable tenderness of divine love and the fortitude of saints.

By exploring each painting in detail, often finding aspects that we never 'knew' were there, *Heaven in Art* is an intimate voyage of discovery. We do not need to be devout, or even believers, to delight in the vivid and beautiful texts and images so aptly paired in this book.

Erika Langmuir
Head of Education, National Gallery, 1988–1995

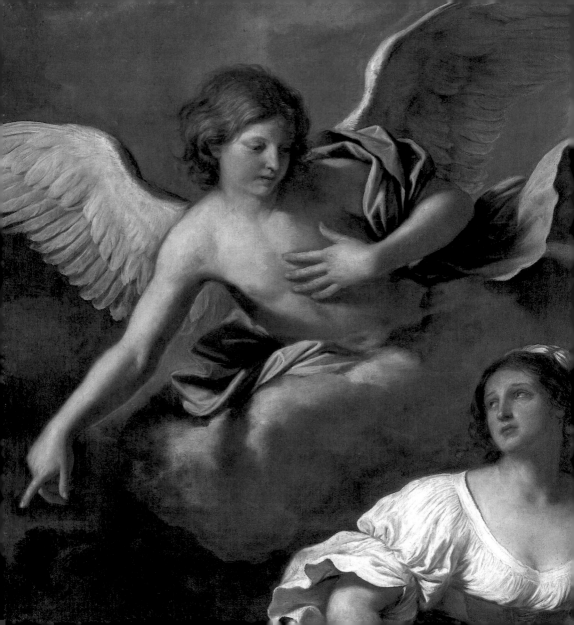

messengers of grace

SANDRO BOTTICELLI (about 1445–1510) Italian
'Mystic Nativity'
1500

Angels we have heard on high
Sweetly singing o'er the plains,
And the mountains in reply
Echoing their joyous strains:
Gloria in excelsis Deo,
Gloria in excelsis Deo.

Shepherds why this jubilee?
Why your joyous strains prolong?
What the gladsome tidings be
Which inspire your heav'nly song?
Gloria in excelsis Deo,
Gloria in excelsis Deo.

Come to Bethlehem and see
Him whose birth the angels sing.
Come adore on bended knee
Christ the Lord, the new-born King.
Gloria in excelsis Deo,
Gloria in excelsis Deo.

Angels We Have Heard on High,
ANONYMOUS, Traditional English Carol, 1855

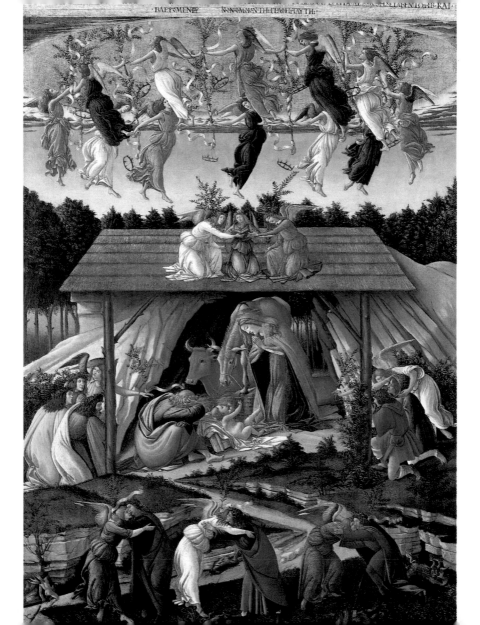

11

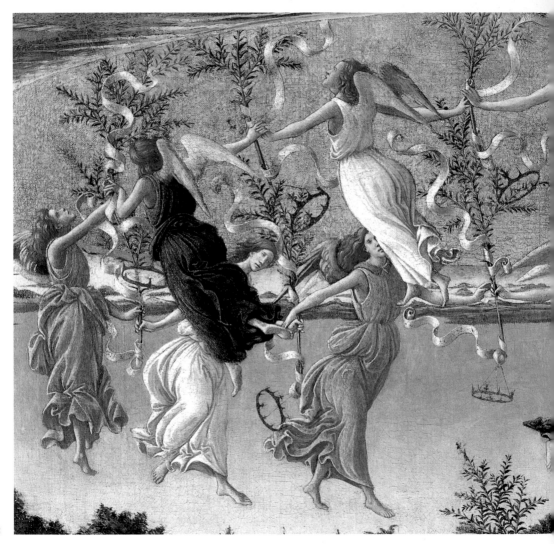

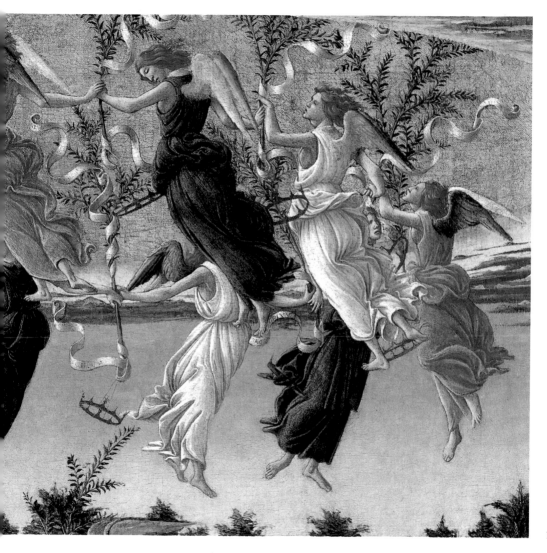

13

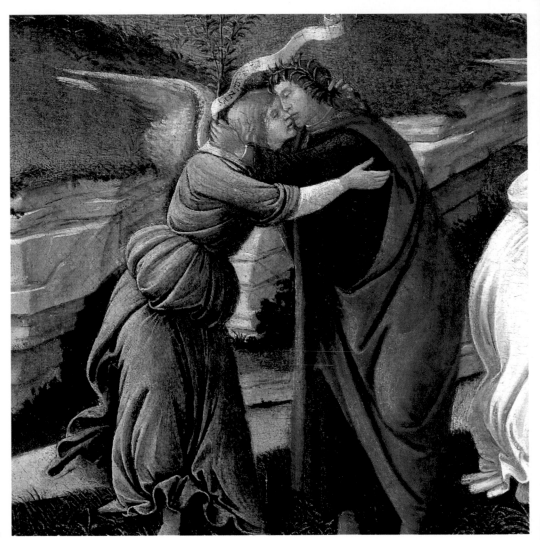

14

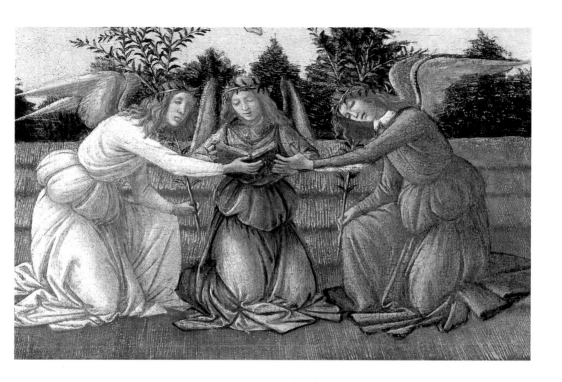

Duccio (active 1278; died 1318/19) Italian
The Annunciation
1311

The angel and the girl are met.
Earth was the only meeting place.
For the embodied never yet
Travelled beyond the shore of space.
The eternal spirits in freedom go.

See, they have come together, see,
While the destroying minutes flow,
Each reflects the other's face
Till heaven in hers and earth in his
Shine steady there. He's come to her
From far beyond the farthest star,
Feathered through time. Immediacy
Of strangest strangeness is the bliss
That from their limbs all movement takes.
Yet the increasing rapture brings
So great a wonder that it makes
Each feather tremble on his wings.

Outside the window footsteps fall
Into the ordinary day
And with the sun along the wall
Pursue their unreturning way.
Sound's perpetual roundabout

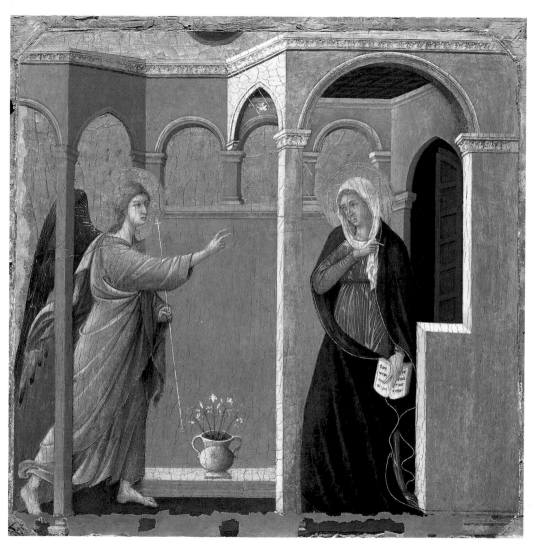

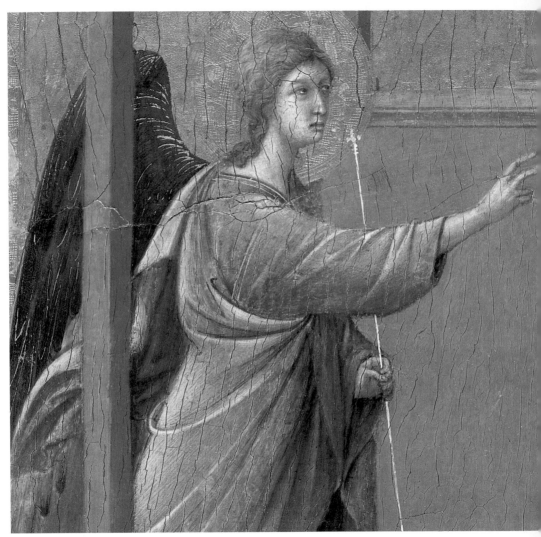

Rolls its numbered octaves out
And hoarsely grinds its battered tune.

But through the endless afternoon
These neither speak nor movement make,
But stare into their deepening trance
As if their gaze would never break.

The Annunciation,
EDWIN MUIR, 1956

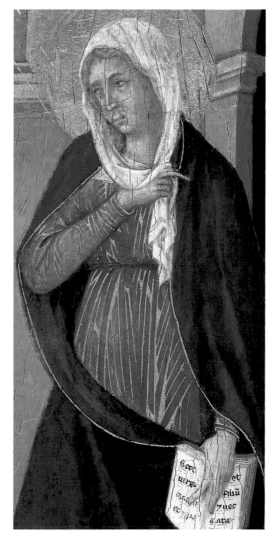

ASSOCIATE OF LEONARDO DA VINCI
(Leonardo da Vinci, 1452–1519, Italian)
An Angel in Red with a Lute
probably about 1490–99

In Heaven a spirit doth dwell
 'Whose heart-strings are a lute;'
None sing so wildly well
As the angel Israfel,
And the giddy stars (so legends tell)
Ceasing their hymns, attend the spell
 Of his voice, all mute.

Tottering above
 In her highest noon,
 The enamoured moon
Blushes with love,
 While, to listen, the red levin
 (With the rapid Pleiads, even,
 Which were seven)
 Pauses in Heaven.

And they say (the starry choir
 And the other listening things)
 That Israfeli's fire
Is owing to that lyre
 By which he sits and sings—
The trembling living wire
 Of those unusual strings.

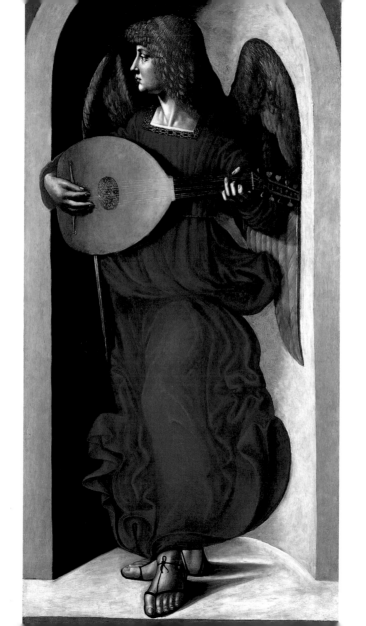

But the skies that angel trod,
　　Where deep thoughts are a duty,
Where Love's a grown-up God,
　　Where the Houri glances are
Imbued with all the beauty
　　Which we worship in a star.

Therefore, thou art not wrong,
　　Israfeli, who despisest
An unimpassioned song;
　To thee the laurels belong,
　　Best bard, because the wisest!
Merrily live, and long!

from *Israfel*,
EDGAR ALLAN POE, 1831

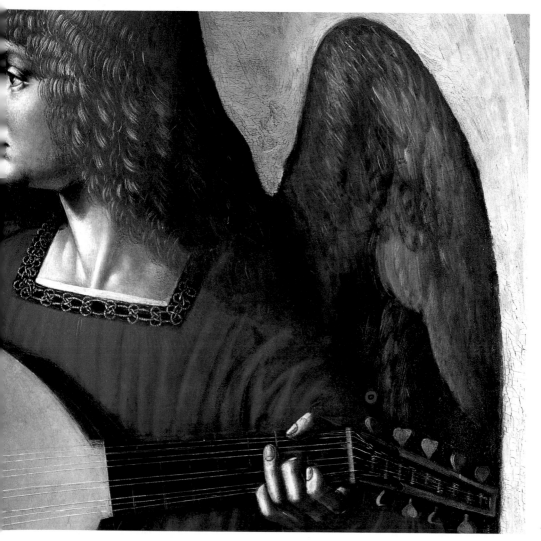

PHILIPPE DE CHAMPAIGNE
(1602–1674) French
The Vision of Saint Joseph
about 1638

As Joseph was a-walking
 He heard an Angel sing:
'This night there shall be born
 Our gracious Heav'nly King;
He neither shall be born
 In housen nor in hall,
Nor in the place of Paradise,
 But in an ox's stall.'

'He neither shall be christen'd
 In white wine nor in red;
But with the fair spring water,
 With which we were christenèd.'
As Joseph was a-walking,
 Thus did the Angel sing;
And Mary's Child at midnight
 Was born to be our King.

<div align="right">

from *As Joseph Was A-walking*,
ANONYMOUS, Traditional French Carol

</div>

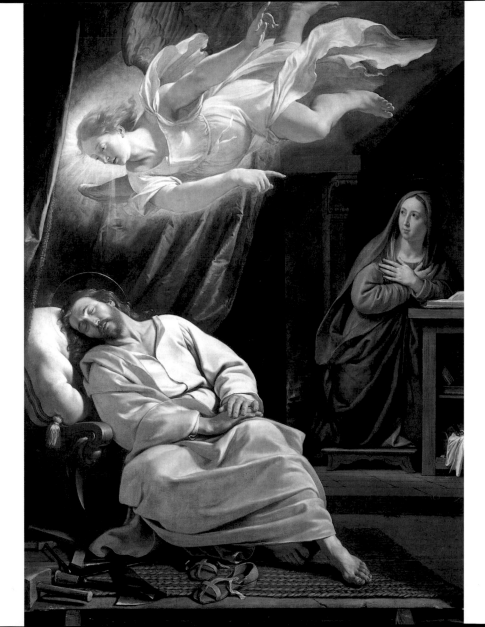

25

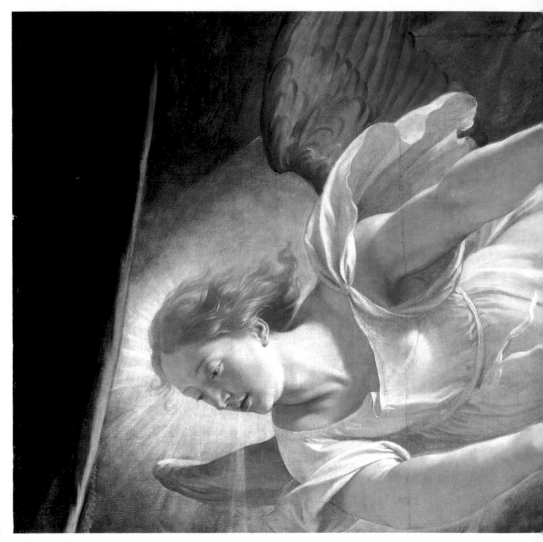

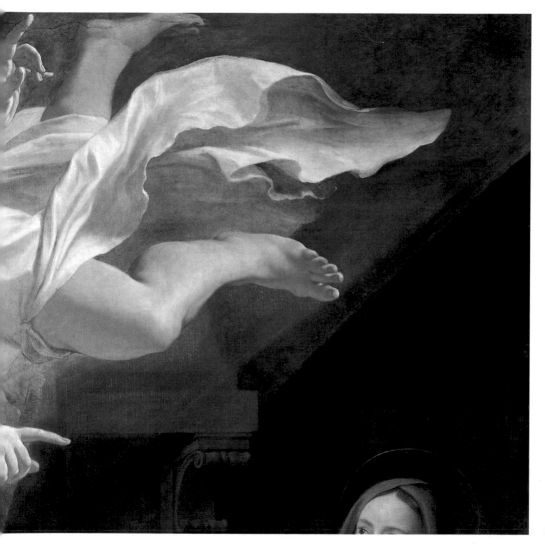

AFTER ADAM ELSHEIMER
(Adam Elsheimer, 1578–1610, German)
Tobias and the Archangel Raphael returning with the Fish
mid-17th century

At last I made bold to ask him to tell us who he was.

'An angel,' he said, quite simply, and set another bird free
and clapped his hands and made it fly away.

A kind of awe fell upon us when we heard him say that,
and we were afraid again; but he said we need not be
troubled, there was no occasion for us to be afraid of an
angel, and he liked us, anyway. He went on chatting as
simply and unaffectedly as ever…Then Seppi asked him
what his own name was, and he said, tranquilly, 'Satan'…

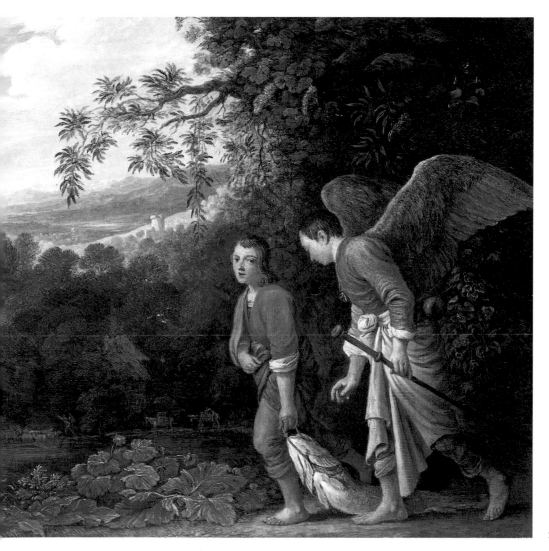

It caught us suddenly, that name did, and our work dropped out of our hands and broke to pieces…Satan laughed, and asked what was the matter. I said, 'Nothing, only it seemed a strange name for an angel.' He asked why.

'Because it's – it's – well, it's his name, you know.'

'Yes – he is my uncle.'

He said it placidly, but it took our breath for a moment and made our hearts beat…'Don't you remember? – he was an angel himself, once.'

'Yes – it's true,' said Seppi; 'I didn't think of that.'

'Before the Fall he was blameless.'

'Yes,' said Nikolaus, 'he was without sin.'

'It is a good family – ours,' said Satan; 'there is not a better. He is the only member of it that has ever sinned.'

from *The Mysterious Stranger*,
MARK TWAIN, published 1916

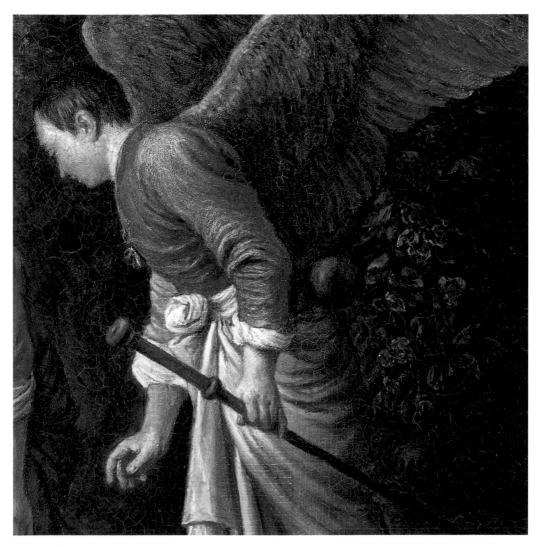

The Wilton Diptych

Richard II presented to the Virgin and Child by his Patron Saint John the Baptist and Saints Edward and Edmund
about 1395–99

Let them praise Thy Name, let them praise Thee, the supercelestial people, Thine angels, who have no need to gaze up at this firmament, or by reading to know of Thy word. For they always behold Thy face, and there read without any syllables in time, what willeth Thy eternal will; they read, they choose, they love. They are ever reading; and that never passes away which they read; for by choosing, and by loving, they read the very unchangeableness of Thy counsel. Their book is never closed, nor their scroll folded up; seeing Thou Thyself art this to them, and art eternally; because Thou hast ordained them above this firmament, which Thou hast firmly settled over the infirmity of the lower people, where they may gaze up and learn Thy mercy, announcing in time Thee Who madest times. For Thy mercy, O Lord, is in the heavens, and Thy truth reacheth unto the clouds. The clouds pass away, but the heaven abideth.

from *Confessions*,
SAINT AUGUSTINE, about 400

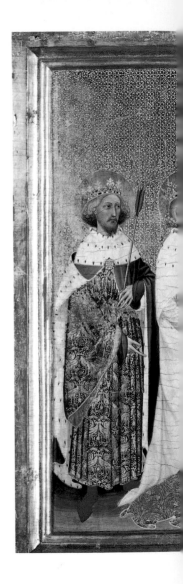

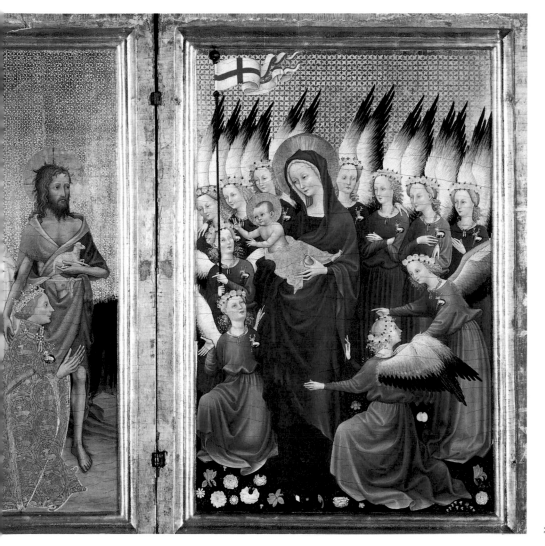

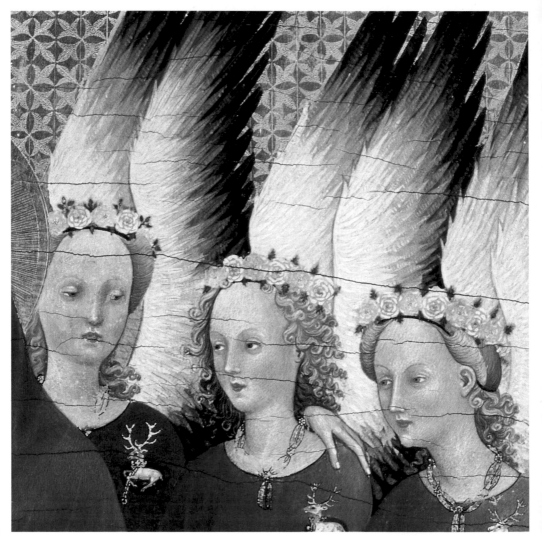

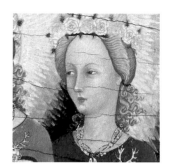

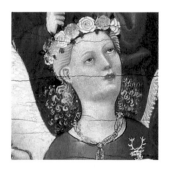

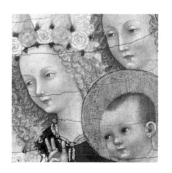

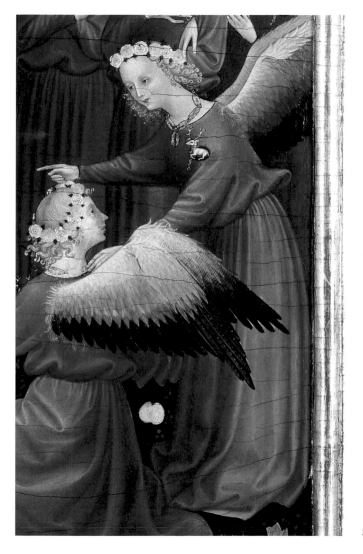

FRANCESCO BOTTICINI
(about 1446–1497) Italian
The Assumption of the Virgin
probably about 1475–76

And at that centre, with their wings expanded,
 More than a thousand jubilant Angels saw I,
 Each differing in effulgence and in kind.
I saw there at their sports and at their songs
 A beauty smiling, which the gladness was
 Within the eyes of all the other saints;
And if I had in speaking as much wealth
 As in imagining, I should not dare
 To attempt the smallest part of its delight.

from 'Paradiso', *Divina Commedia*
DANTE, 1318–21

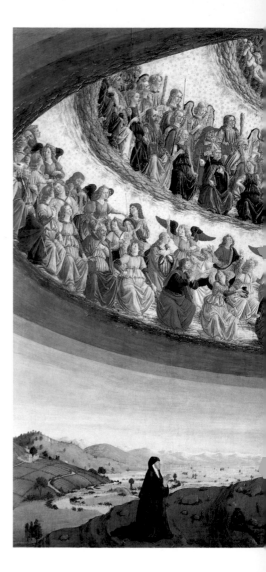

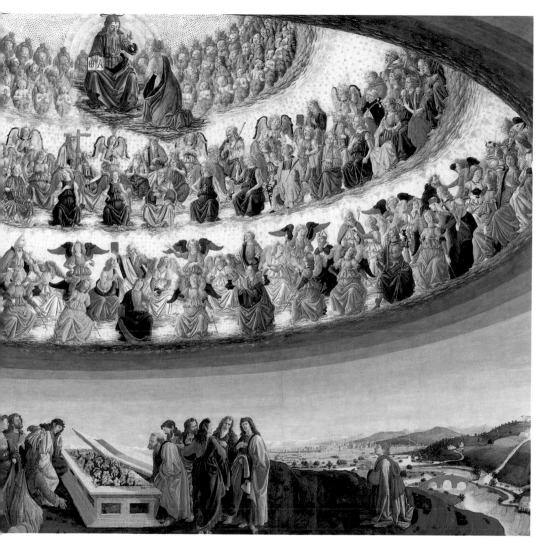

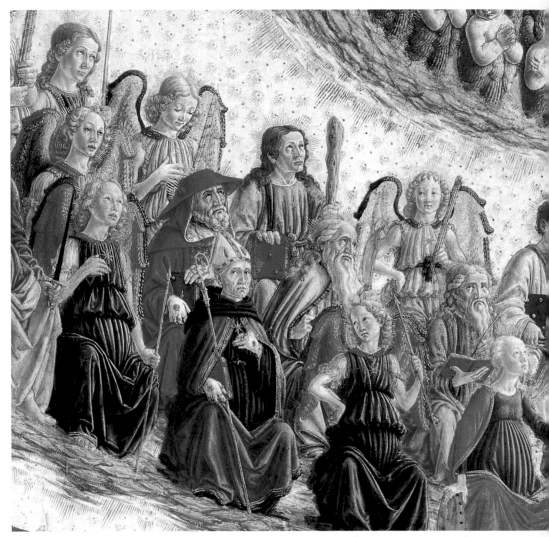

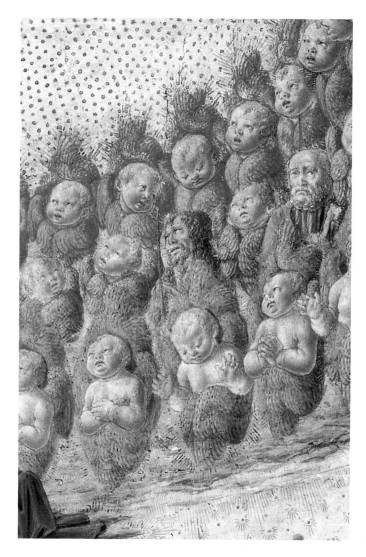

Lorenzo Costa (about 1459/60–1535) Italian
The Adoration of the Shepherds with Angels
about 1499

Run, shepherds, run where Bethlem blest appears,
We bring the best of news, be not dismayed,
A Saviour there is born more old than years,
Amidst heaven's rolling heights this earth who stayed:
In a poor cottage inned, a virgin maid
A weakling did him bear, who all upbears;
There is he, poor swaddled, in a manger laid,
To whom too narrow swaddlings are our spheres:
Run, shepherds , run, and solemnize his birth,
This is that night – no, day, grown great with bliss,
In which the power of Satan broken is;
In heaven be glory, peace unto earth!
 Thus singing, through the air the angels swam,
 And cope of stars re-echoed the same.

The Angels for the Nativity of our Lord,
William Drummond, early 17th century

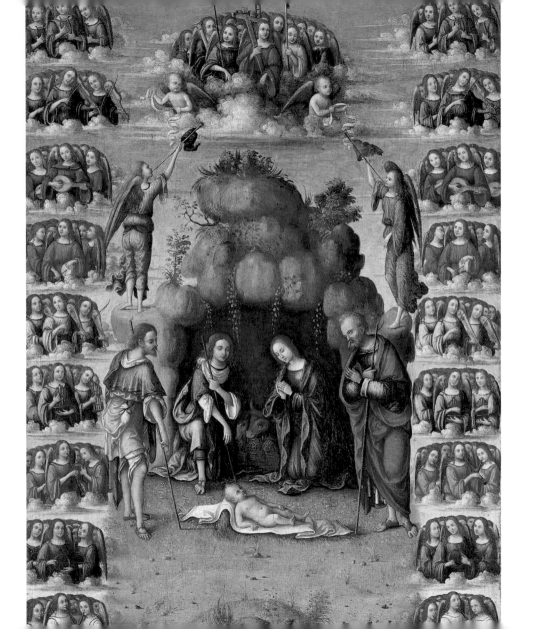

 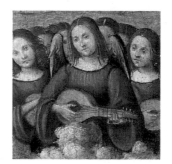 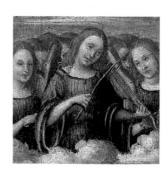

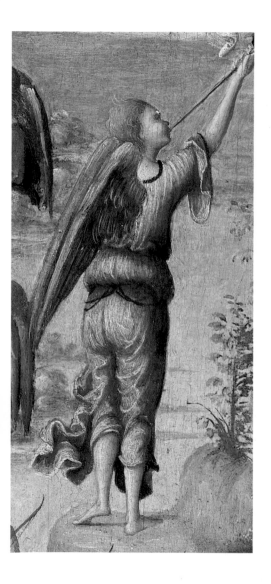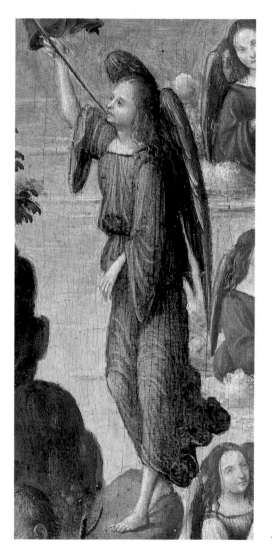

43

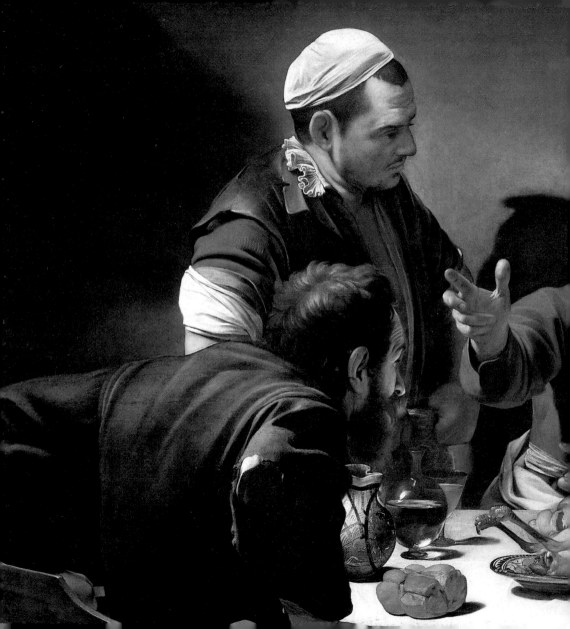

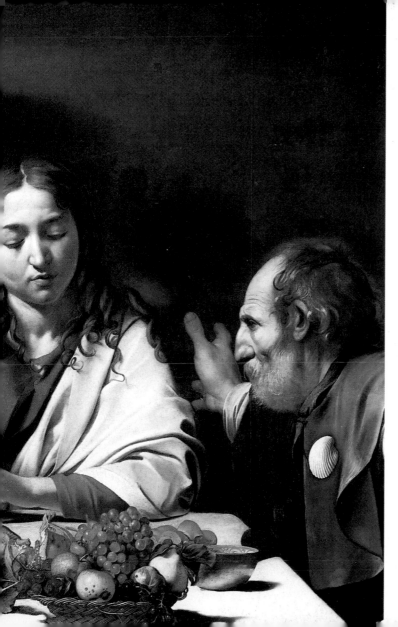

the light of the world

GEERTGEN TOT SINT JANS
(about 1455–65; died about 1485–95) Dutch
The Nativity, at Night
late 15th century

Mary was watching tenderly
 Her little son;
Softly the mother sang to sleep
 Her darling one.
Sleep, lovely Child, be now at rest,
 Thou Son of Light;
Sleep, pretty fledgling, in Thy nest
 All thro' the night.

Mary has spread your manger bed,
 Sleep, little Dove,
God's creatures all draw near to praise,
 Crown of my love.
Sleep little Pearl, Creator, Lord,
 Our homage take;
Bees bring you honey from their hoard,
 When you wake.

<div align="right">

Mary Was Watching,
ANONYMOUS, Traditional Czech Carol

</div>

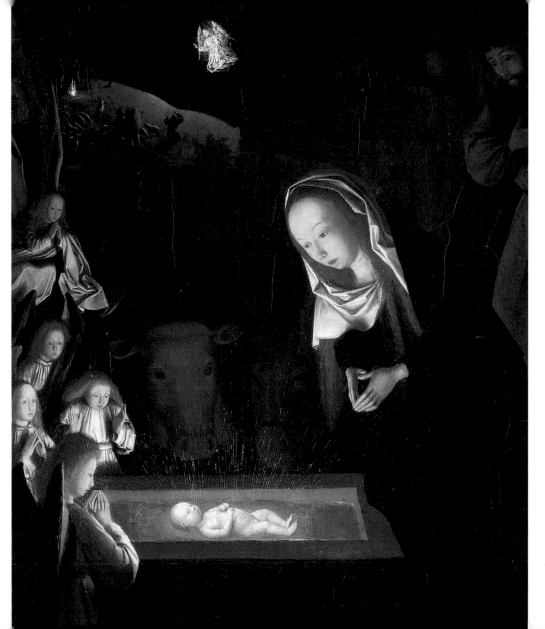

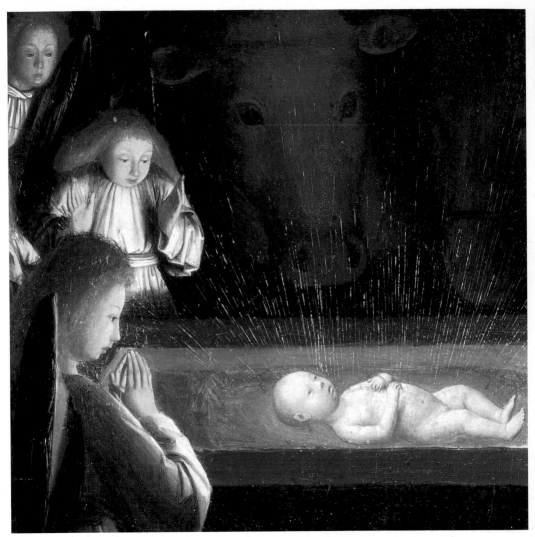

48

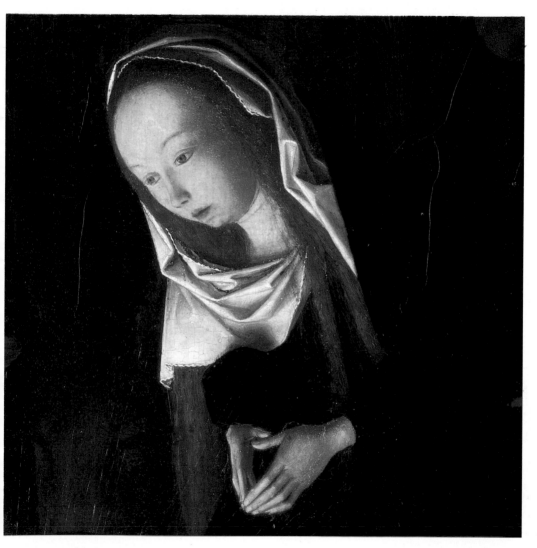

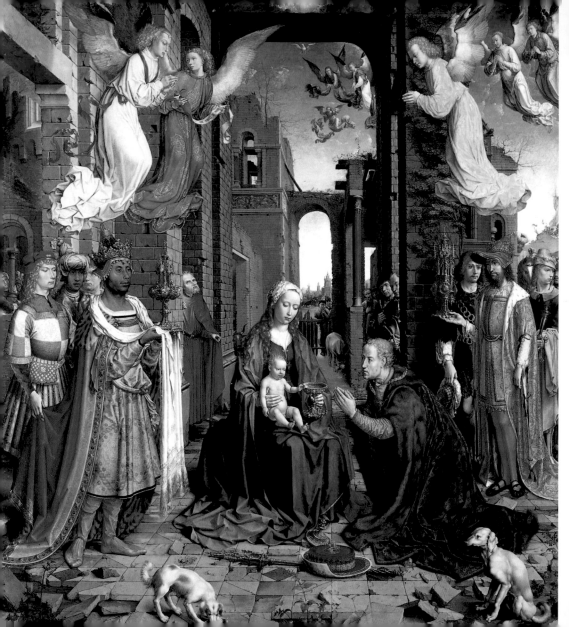

JAN GOSSAERT (active 1503; died 1532) Flemish
The Adoration of the Kings
1500–15

Now as at all times I can see in the mind's eye,
In their stiff, painted clothes, the pale unsatisfied ones
Appear and disappear in the blue depth of the sky
With all their ancient faces like rain-beaten stones,
And all their helms of silver hovering side by side,
And all their eyes still fixed, hoping to find once more,
Being by Calvary's turbulence unsatisfied,
The uncontrollable mystery on the bestial floor.

The Magi,
WILLIAM BUTLER YEATS, 1914

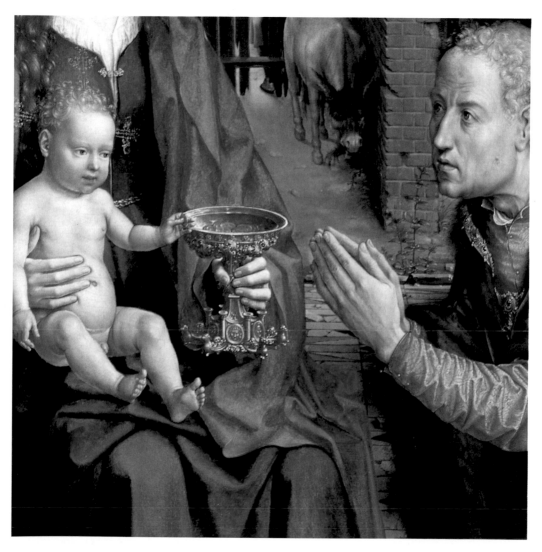

53

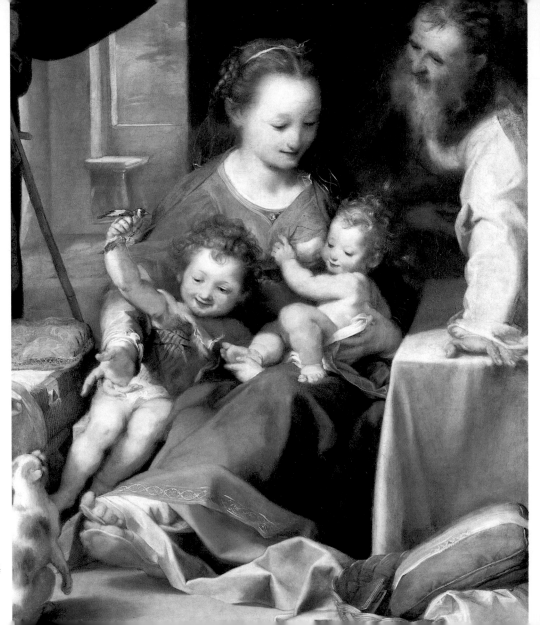

FEDERICO BAROCCI (1535–1612) Italian
The Madonna and Child with Saint Joseph and the Infant
Baptist (La Madonna del Gatto)
probably about 1575

See what a charming smile I bring,
Which no one can resist;
For I have a wondrous thing—
The Fact that I exist.

And I have found another, which
I now proceed to tell.
The world is so sublimely rich
That you exist as well.

Fact One is lovely, so is Two,
But O the best is Three:
The fact that I can smile at you,
And you can smile at me.

The Plain Facts, By a PLAIN but AMIABLE Cat,
RUTH PITTER, 20th century

56

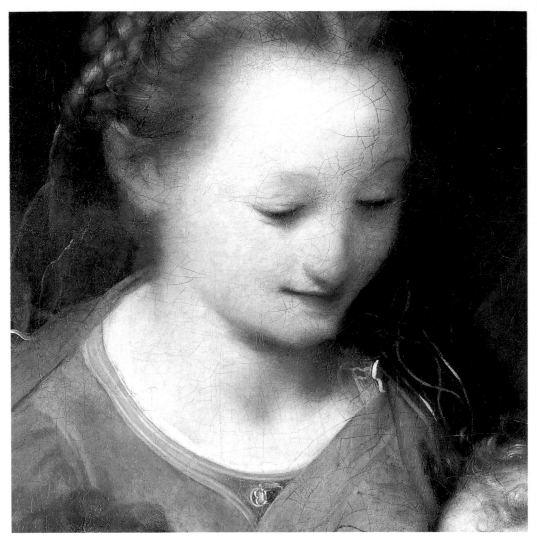

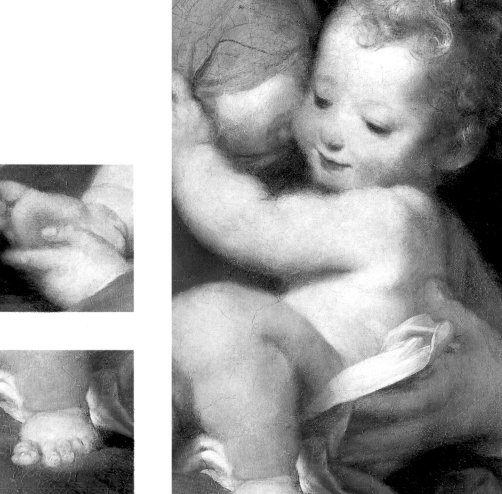

59

GUIDO RENI (1575–1642) Italian
Christ embracing Saint John the Baptist
about 1640

You, through whose face
all lovely faces look,
and are resolved for ever
in your soul's true mirror:
you, in whose unspoken words
the irrevocable voices speak again,
making in this less divided moment
the remembered music that the heart accords.

O you who are myself and yet another,
who are the world, and the unknown
through which the town, the river,
the familiar gardens and the fountain shines;
here is my hand, and with it let all hands
be given, and be held, in yours and mine.

Meeting with a Stranger,
JAMES KIRKUP, 1947

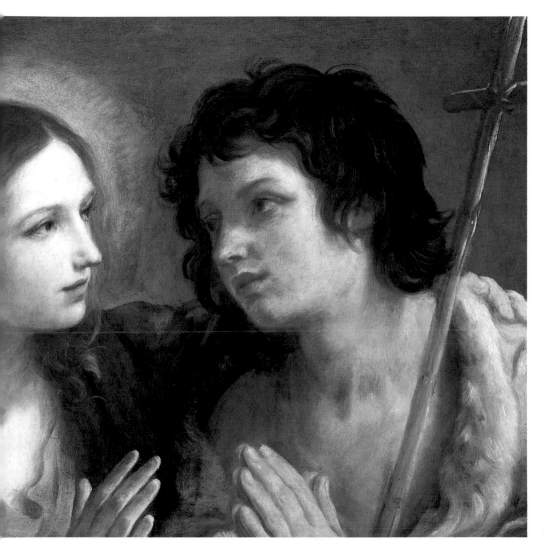

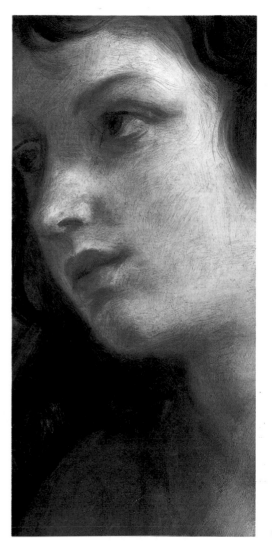

Yes, love (he thought again with perfect distinctness), but not that love that loves for something, to gain something, or because of something, but that love that I felt for the first time, when dying, I saw my enemy and yet loved him. I knew that feeling of love which is the very essence of the soul, for which no object is needed. And I know that blissful feeling now too. To love one's neighbours; to love one's enemies. To love everything – to love God in all His manifestations. Some one dear to one can be loved with human love; but an enemy can only be loved with divine love. And that was why I felt such joy when I felt that I loved that man. What happened to him? Is he still alive?…Loving with human love, one may pass from love to hatred; but divine love cannot change. Nothing, not even death, nothing can shatter it. It is the very nature of the soul…

Love is life. All, all that I understand, I understand only because I love. All is, all exists only because I love. All is bound up in love alone. Love is God, and dying means for me a particle of love, to go back to the universal and eternal source of love.

from *War and Peace*,
Leo Tolstoy, 1863–69

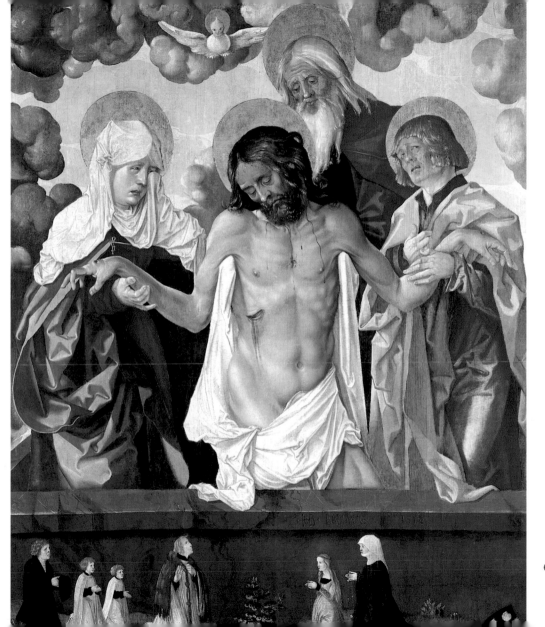

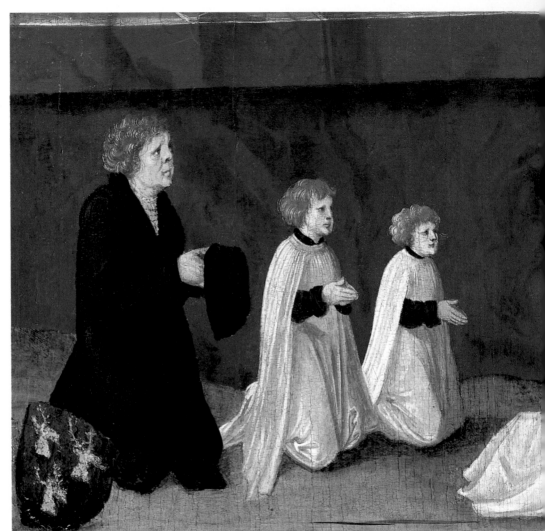

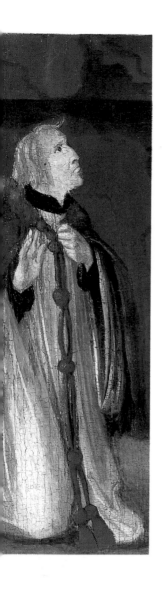

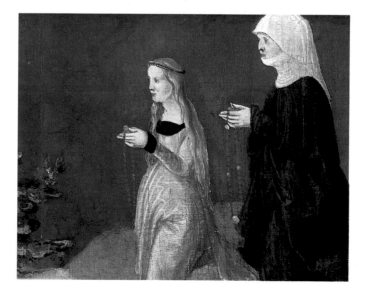

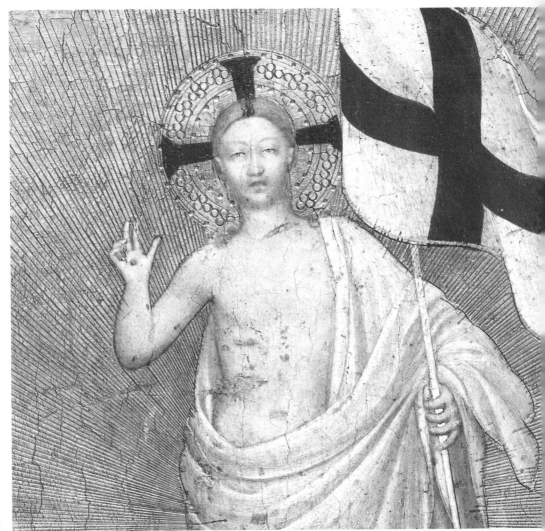

FRA ANGELICO (about 1395–1455) Italian
Christ Glorified in the Court of Heaven
probably 1428–30

The Lord is king, with majesty enrobed;
the Lord has robed himself with might,
he has girded himself with power.

The world you made firm, not to be moved;
your throne has stood firm from of old.
From all eternity, O Lord, you are.

The waters have lifted up, O Lord,
the waters have lifted up their voice,
the waters have lifted up their thunder.

Greater than the roar of mighty waters,
more glorious than the surgings of the sea,
the Lord is glorious on high.

Truly your decrees are to be trusted.
Holiness is fitting to your house,
O Lord, until the end of time.

Psalm 93

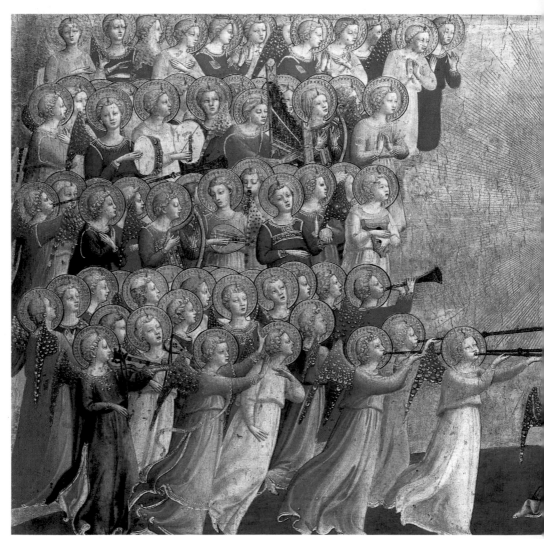

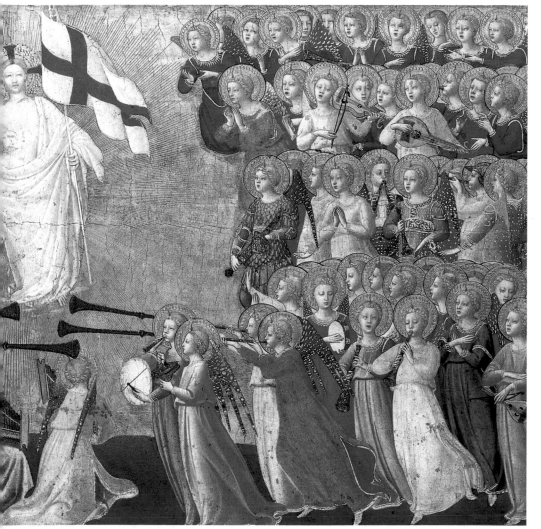

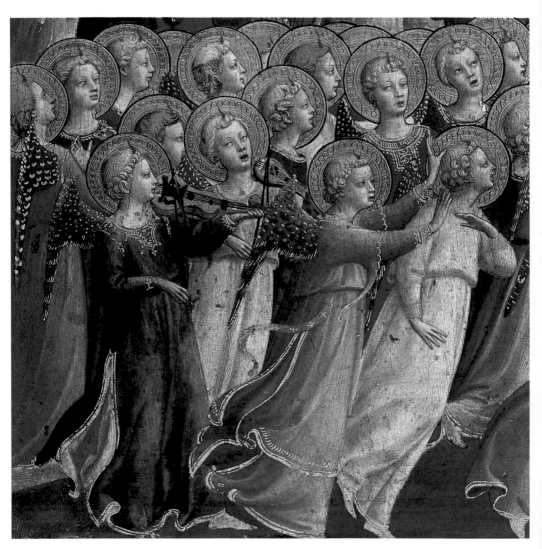

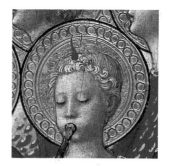

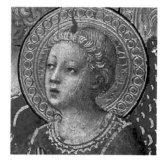

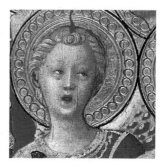

73

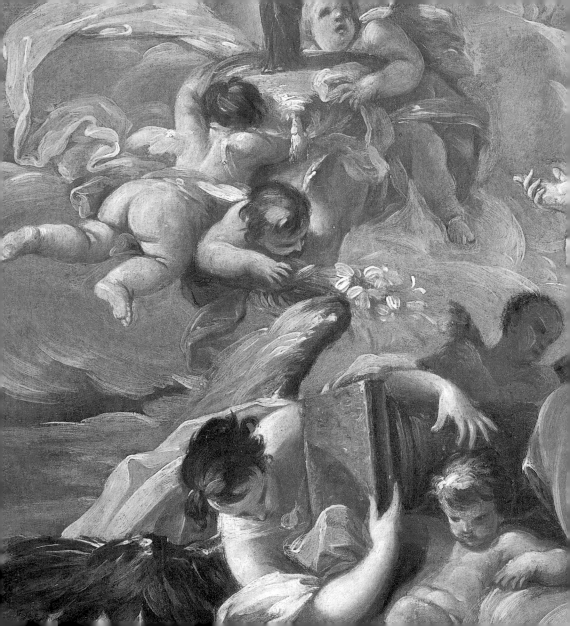

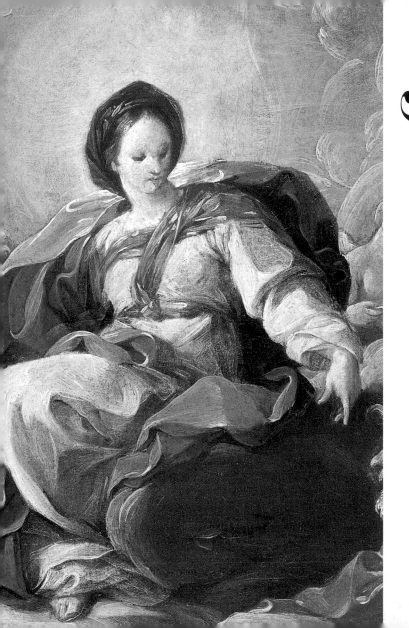

queen of
heaven

ATTRIBUTED TO ANTONELLO DA MESSINA
(active 1456; died 1479) Italian
The Virgin and Child
probably about 1460–70

I sing of a maiden
 That is matchless.
King of all kings
 For her son she chose.

He came all so still
 Where his mother was,
As dew in April
 That falleth on the grass.

He came all so still
 To his mother's bower,
As dew in April
 That falleth on the flower.

He came all so still—
 There his mother lay,
As dew in April
 That falleth on the spray.

Mother and maiden
 Was never none but she;
Well may such a lady
 God's mother be.

Mother and Maiden,
ANONYMOUS, early 16th century

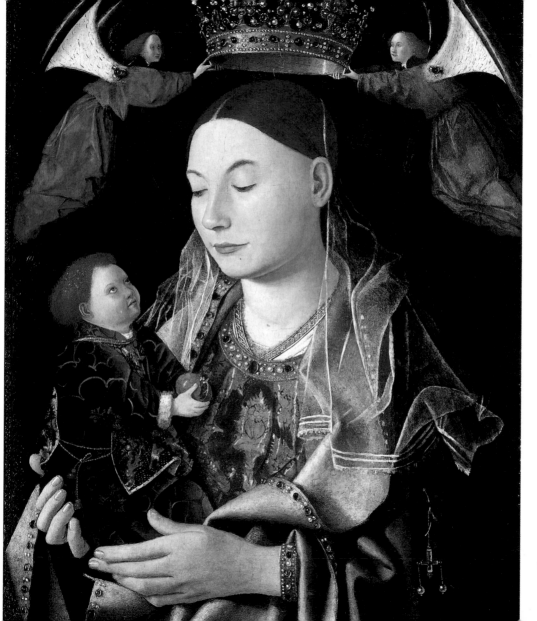

 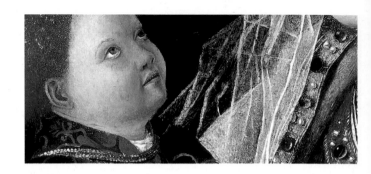

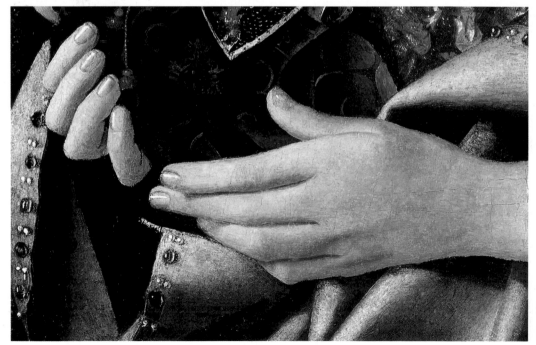

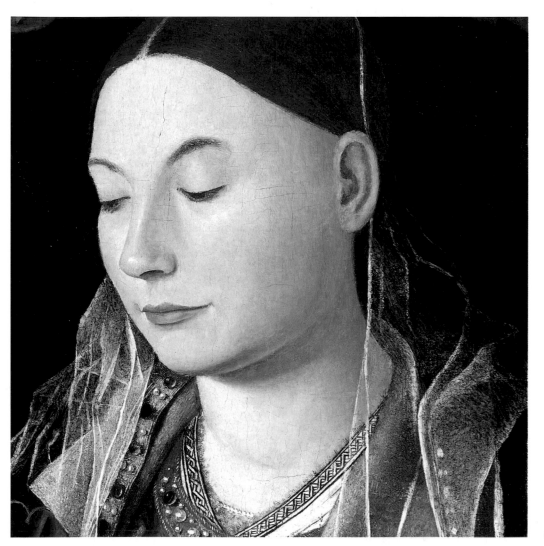

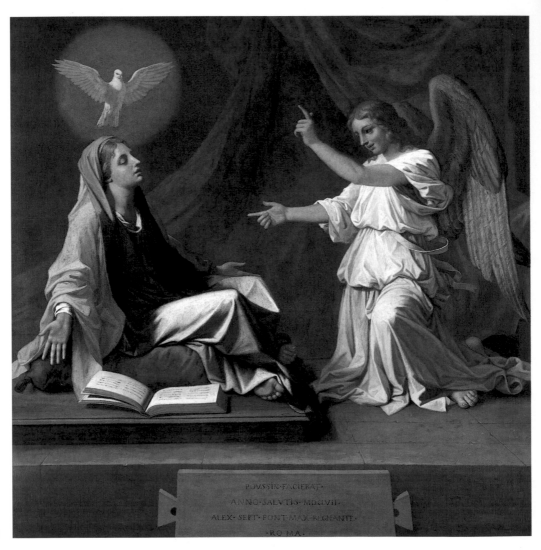

NICOLAS POUSSIN (1594–1665) French
The Annunciation
1657

Waking alone in a multitude of loves when morning's light
Surprised in the opening of her nightlong eyes
His golden yesterday asleep upon the iris
And this day's sun leapt up the sky out of her thighs
Was miraculous virginity old as loaves and fishes,
Though the moment of a miracle is unending lightning
And the shipyards of Galilee's footprints hide a navy
 of doves.

from *On the Marriage of a Virgin*,
DYLAN THOMAS, 1946

MARGARITO OF AREZZO
(active 1262?) Italian
The Virgin and Child Enthroned, with
Scenes of the Nativity and the Lives of the Saints
1260s

Our Lady, too small for her canopy,
Sits near the altar. There's no comeliness
At all or charm in that expressionless
Face with its heavy eyelids. As before,
This face, for centuries a memory,
Non est species, neque decor,
Expressionless, expresses God: it goes
Past castled Sion. She knows what God knows,
Not Calvary's Cross nor crib at Bethlehem
Now, and the world shall come to Walsingham.

from *Our Lady of Walsingham*,
ROBERT LOWELL, 1946

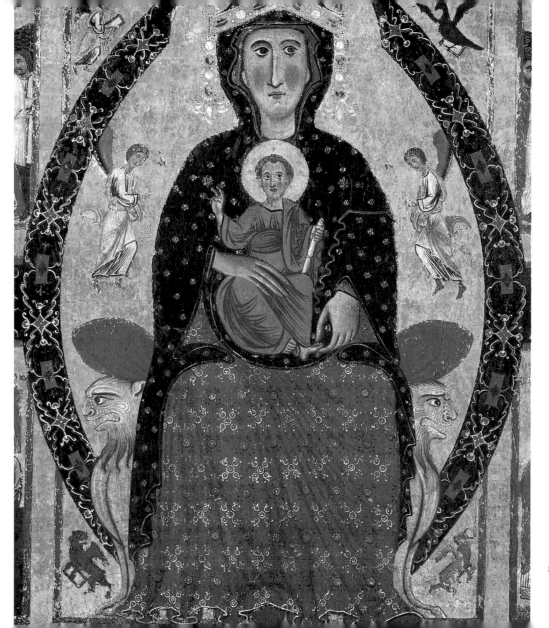

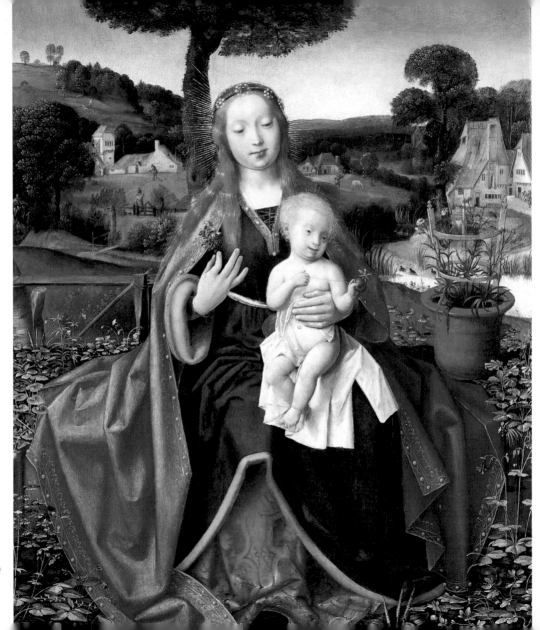

The Virgin and Child in a Landscape
early 16th century

A baby is born us bliss to bring;
A maiden I heard lullay sing:
'Dear son, now leave thy weeping,
Thy father is the king of bliss.'

'Nay, dear mother, for you weep I not,
But for thinges that shall be wrought
Or that I have mankind i-bought:
Was there never pain like it iwis.'

'Peace, dear son, say thou me not so.
Thou art my child, I have no mo.
Alas! that I should see this woe:
It were to me great heaviness.'

'My handes, mother, that ye now see,
They shall be nailéd on a tree;
My feet, also, fastened shall be:
Full many shall weep that it shall see.'

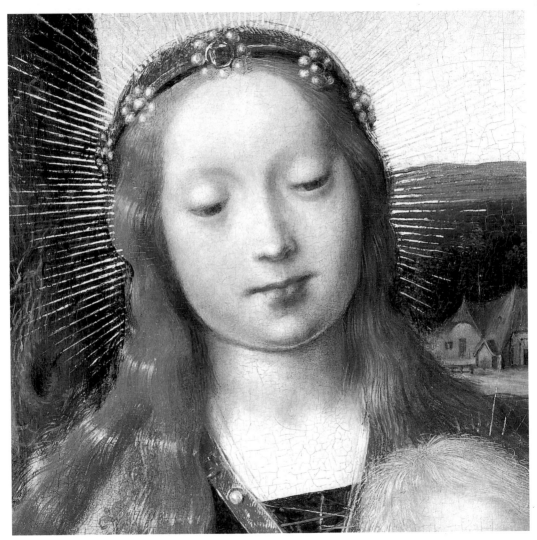

'Alas! dear son, sorrow is now my hap;
To see the child that sucks my pap
So ruthfully taken out of my lap:
It were to me great heaviness.'

'Also, mother, there shall a spear
My tendere heart all to-tear;
The blood shall cover my body there:
Great ruthe it shall be to see.'

'Ah! dear son, that is a heavy case.
When Gabriel kneeled before my face
And said, "Hail! Lady, full of grace,"
He never told me nothing of this.'

'Dear mother, peace, now I you pray,
And take no sorrow for that I say,
But sing this song, "By, by, lullay,"
To drive away all heaviness.'

A Baby is Born,
ANONYMOUS, 15th century

JUAN DE VALDES LEAL (1622–1690) Spanish
The Immaculate Conception of the Virgin, with Two Donors
probably 1661

WILD air, world-mothering air,
Nestling me everywhere,
That each eyelash or hair
Girdles; goes home betwixt
The fleeciest, frailest-flixed
Snowflake; that's fairly mixed
With, riddles, and is rife
In every least thing's life;
This needful, never spent,
And nursing element;
My more than meat and drink,
My meal at every wink;
This air, which, by life's law,
My lung must draw and draw
Now but to breathe its praise,
Minds me in many ways
Of her who not only
Gave God's infinity
Dwindled to infancy
Welcome in womb and breast,
Birth, milk, and all the rest
But mothers each new grace
That does now reach our race—

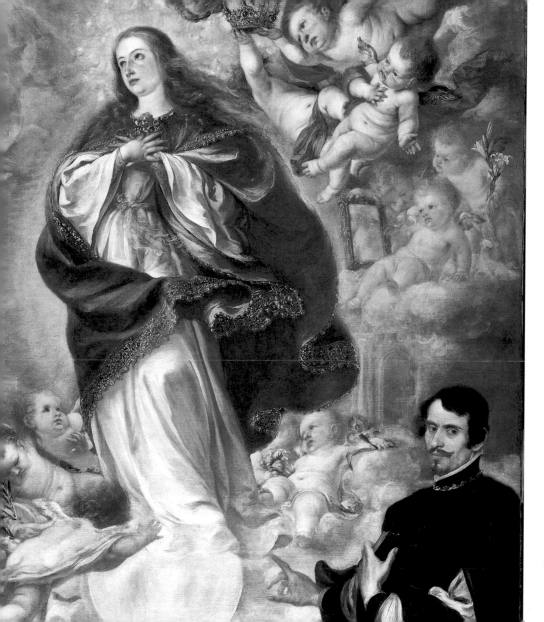

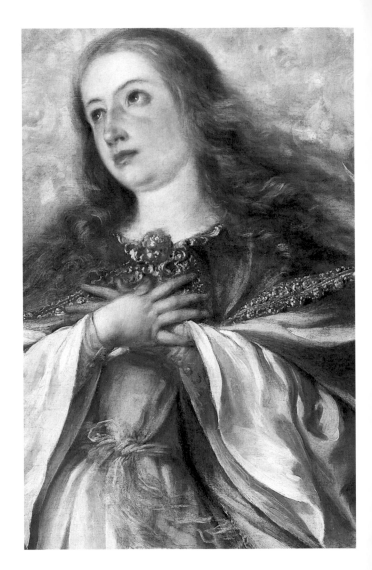

Mary Immaculate,
Merely a woman, yet
Whose presence, power is
Great as no goddess's
Was deemèd, dreamèd; who
This one work has to do—
Let all God's glory through,
God's glory which would go
Through her and from her flow
Off, and no way but so.
 I say that we are wound
With mercy round and round
As if with air: the same
Is Mary, more by name.
She, wild web, wondrous robe,
Mantles the guilty globe,
Since God has let dispense
Her prayers his providence:
Nay, more than almoner,
The sweet alms' self is her
And men are meant to share
Her life as life does air.

from *The Blessed Virgin*
compared to the Air we Breathe.
GERARD MANLEY HOPKINS, 1883

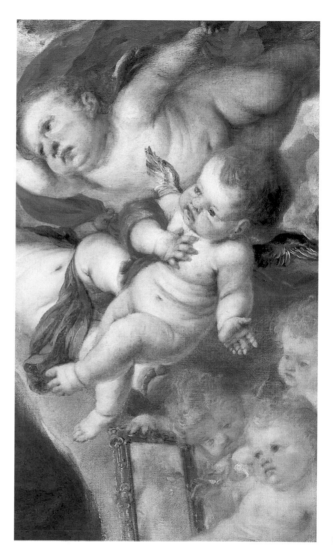

Guido Reni (1575–1642)
Italian
The Coronation of the Virgin
about 1607

Lady, flower of alle thing,
 Rosa sine spina,
Thou bore Jesu, heavenes king,
 Gratia divina.
Of alle thou bear'st the prize,
Lady, queen of Paradise
 Electa.

from *In Praise of Mary*,
Anonymous, 13th century

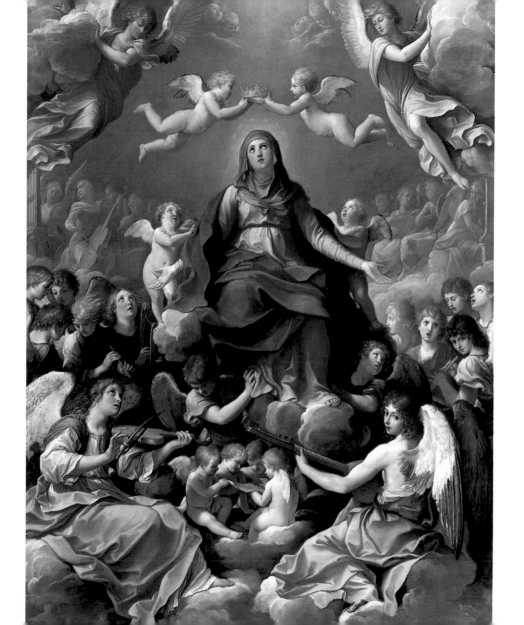

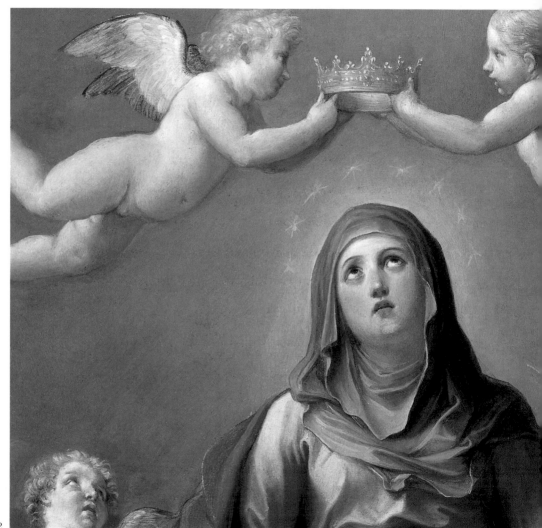

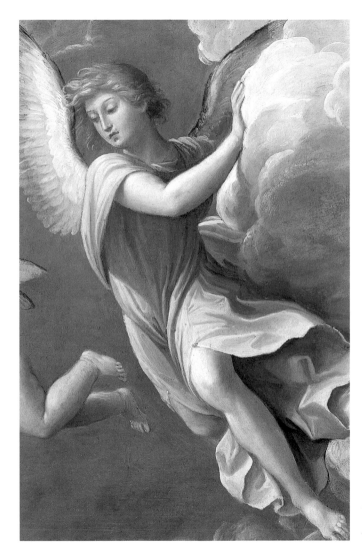

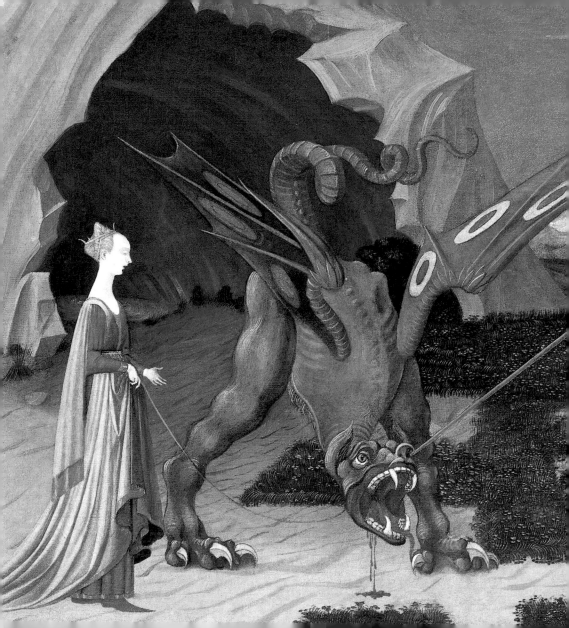

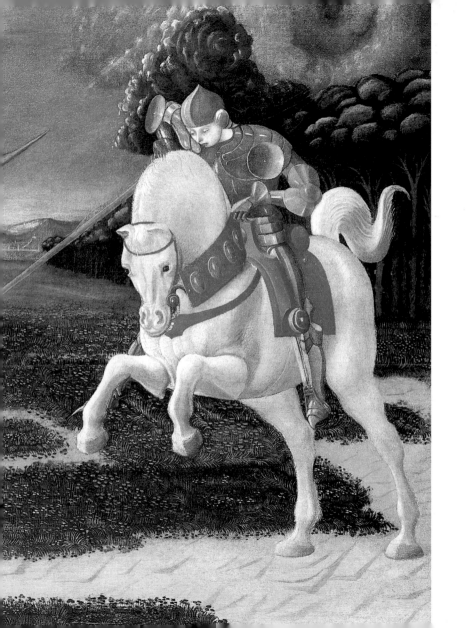

saints

FRA FILIPPO LIPPI
(born about 1406; died 1469) Italian
Seven Saints
late 1450s?

The good are vulnerable
As any bird in flight,
They do not think of safety,
Are blind to possible extinction
And when most vulnerable
Are most themselves.
The good are real as the sun,
Are best perceived through clouds
Of casual corruption
That cannot kill the luminous sufficiency
That shines on city, sea and wilderness,
Fastidiously revealing
One man to another,
Who yet will not accept
Responsibilities of light.
The good incline to praise,
To have the knack of seeing that
The best is not destroyed
Although forever threatened.
The good go naked in all weathers,
And by their nakedness rebuke
The small protective sanities

That hide men from themselves.
The good are difficult to see
Though open, rare, destructible;
Always, they retain a kind of youth,
The vulnerable grace
Of any bird in flight,
Content to be itself,
Accomplished master and potential victim,
Accepting what the earth or sky intends.
I think that I know one or two
Among my friends.

The Good,
BRENDAN KENNELLY, 1967

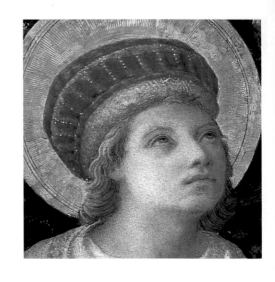

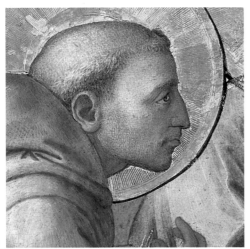

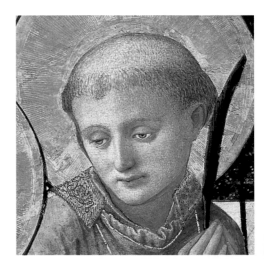

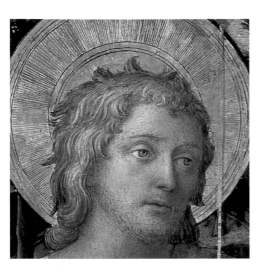 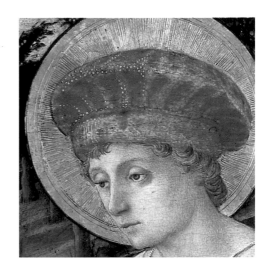

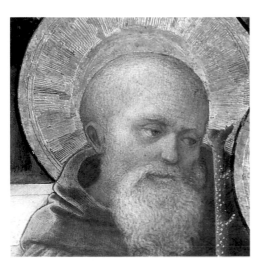 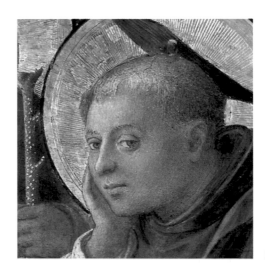

111

PIETRO DA CORTONA (1596–1669) Italian
Saint Cecilia
1620–25

From harmony, from heav'nly harmony
 This universal frame began:
 When Nature underneath a heap
 Of jarring atoms lay,
 And could not heave her head,
The tuneful voice was heard from high:
 'Arise, ye more than dead.'
Then cold, and hot, and moist, and dry,

In order to their stations leap,
 And Music's pow'r obey.
From harmony, from heav'nly harmony
 This universal frame began:
 From harmony to harmony
Thro' all the compass of the notes it ran,
The diapason closing full in Man.

When passion cannot Music raise and quell!
 When Jubal struck the corded shell,
 His list'ning brethren stood around,
 And, wond'ring, on their faces fell
 To worship that celestial sound.
Less than a god they thought there could not dwell
 Within the hollow of that shell
 That spoke so sweetly and so well,
What passion cannot Music raise and quell!

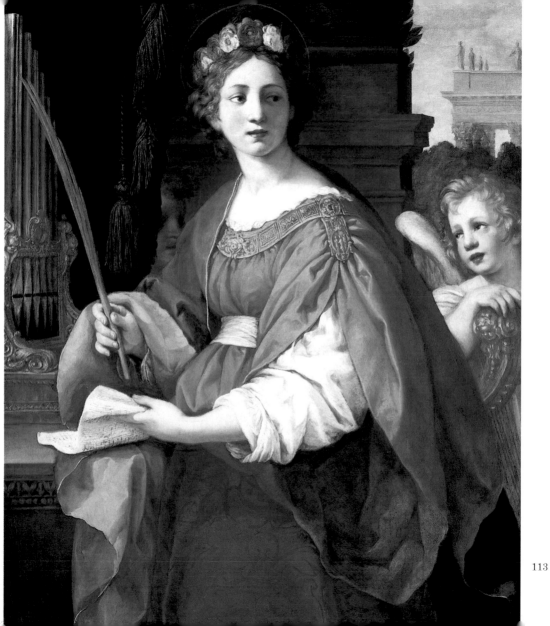

113

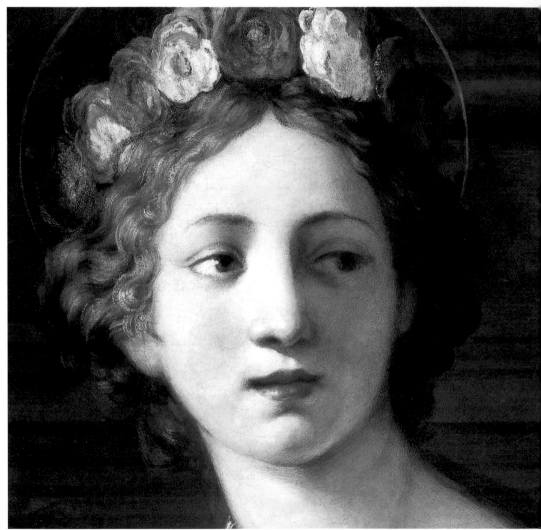

The Trumpet's loud clangour
Excites us to arms,
With shrill notes of anger,
And mortal alarms.
The double double double beat
Of the thund'ring Drum
Cries: 'Hark! the foes come;
Charge, charge, 't is too late to retreat.'
The soft complaining Flute
In dying notes discovers
The woes of hopeless lovers,
Whose dirge is whisper'd by the warbling Lute.

Sharp Violins proclaim
Their jealous pangs, and desperation,
Fury, frantic indignation,
Depth of pains, and height of passion,
For the fair, disdainful dame.

But O! what art can teach,
What human voice can reach,
The sacred Organ's praise?
Notes inspiring holy love,
Notes that wing their heav'nly ways
To mend the choirs above.

Orpheus could lead the savage race;
And trees uprooted left their place,
 Sequacious of the lyre;
But bright Cecilia rais'd the wonder high'r:
When to her Organ vocal breath was giv'n,
And angel heard, and straight appear'd,
 Mistaking earth for heav'n.

As from the pow'r of sacred lays
 The spheres began to move,
And sung the great Creator's praise
 To all the blest above;
So, when the last and dreadful hour
This crumbling pageant shall devour,
The Trumpet shall be heard on high,
The dead shall live, the living die,
And Music shall untune the sky.

from *A Song for St Cecilia's Day*
JOHN DRYDEN, 1687

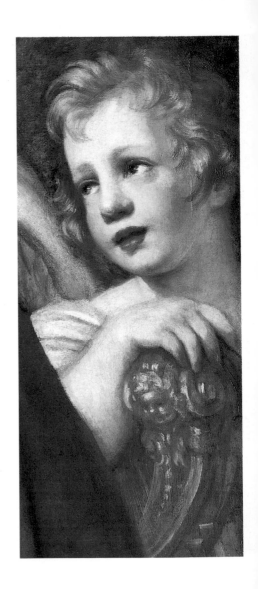

116

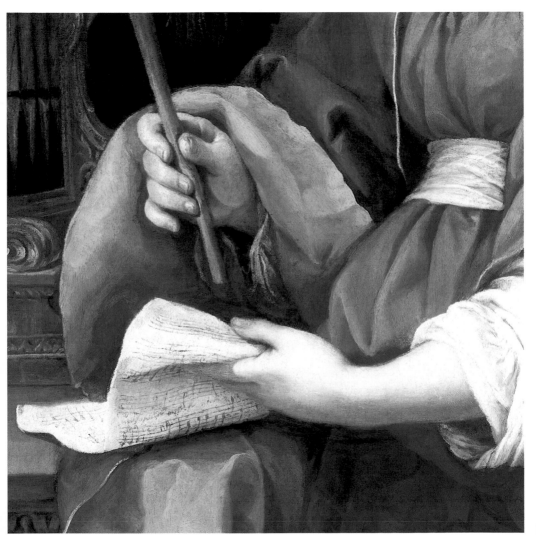

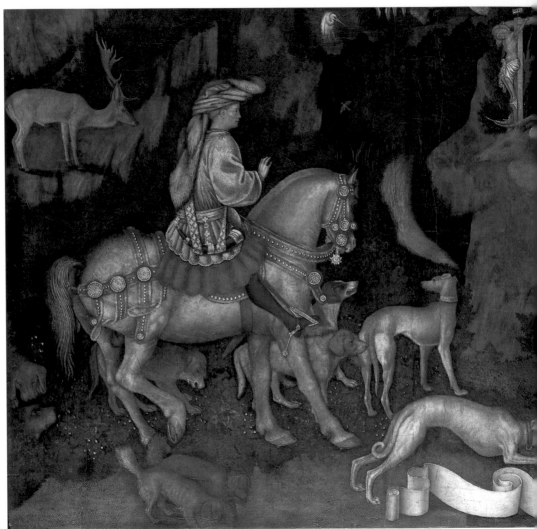

PISANELLO (about 1395–probably 1455) Italian
The Vision of Saint Eustace
mid-15th century

Let man and beast appear before him, and magnify his
 name together.
Let Noah and his company approach the throne of Grace
 and do homage to the Ark of their Salvation.
Let Abraham present a Ram, and worship the God of his
 Redemption.
Let Isaac, the Bridegroom, kneel with his Camels, and bless
 the hope of his pilgrimage.
Let Jacob, and his speckled Drove adore the good Shepherd
 of Israel.
Let Esau offer a scape Goat for his seed…
Let Nimrod, the mighty hunter, bind a Leopard to the
 altar…

Let Daniel come forth with a Lion, and praise God…
Let Naphthali with an Hind give glory…
Let Aaron, the high priest, sanctify a Bull…

Let Abiathar with a Fox praise the name of the Lord…
Let Moses, the Man of God, bless with a Lizard, in the sweet
 majesty of good-nature, and magnanimity of meekness.
Let Joshua praise God with an Unicorn…

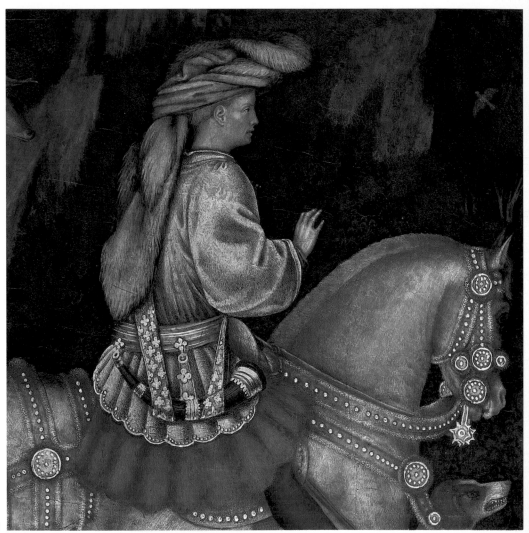

Let David bless with the Bear...
Let Solomon praise with the Ant...

Let Tobias bless Charity with his Dog...
Let Anna bless God with the Cat...
Let Benaiah praise with the Asp...
Let Barzillai bless with the Snail...
Let Joab with the Horse worship the Lord God of Hosts
Let Shemaiah bless God with the Caterpillar...

Let Iddo praise the Lord with the Moth—the writings of
 man perish as the garment, but the Book of God
 endureth for ever.
Let Nebuchadnezzar bless with the Grasshopper—the pomp
 and vanities of the World are as the herb of the field,
 but the glory of the Lord increaseth for ever.

from *Jubilate Agno*,
CHRISTOPHER SMART, 1759–63

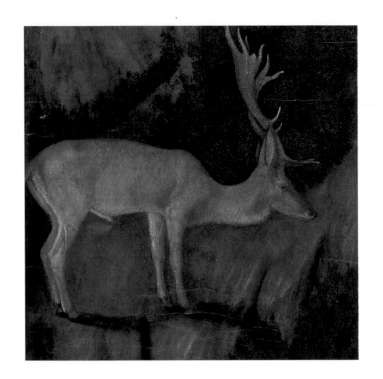

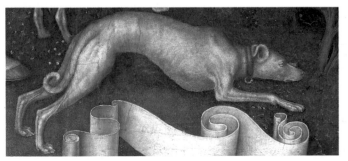

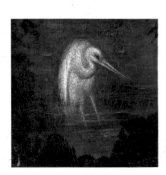

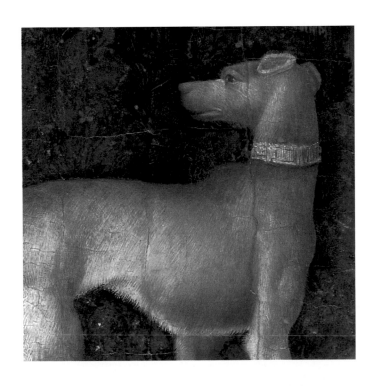

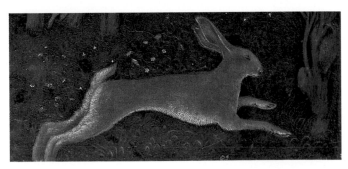

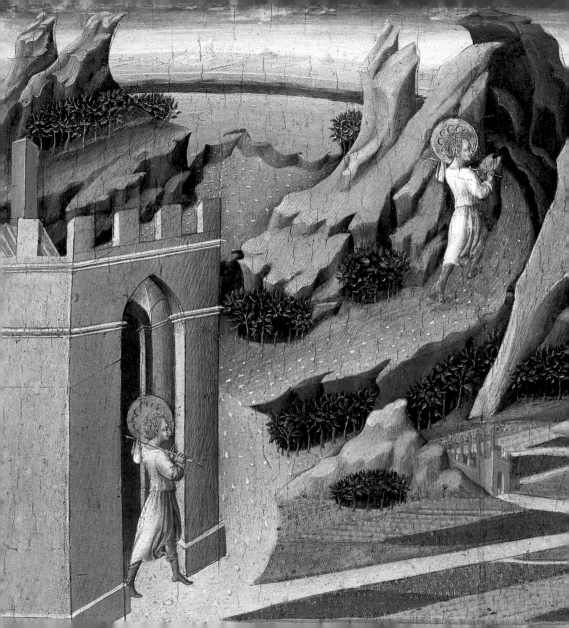

GIOVANNI DI PAOLO (active by 1417; died 1482) Italian
Saint John the Baptist retiring to the Desert
probaby about 1453

The last and greatest herald of heaven's king,
Girt with rough skins, hies to the deserts wild,
Among that savage brood the woods forth bring
Which he than man more harmless found and mild:

His food was locusts, and what young doth spring,
With honey that from virgin hives distilled;
Parched body, hollow eyes, some uncouth thing
Made him appear long since from earth exiled.

There burst he forth: 'All ye, whose hopes rely
On God, with me amidst these deserts mourn;
Repent, repent, and from old errors turn.'
Who listened to his voice, obeyed his cry?

 Only the echoes which he made relent,
 Rung from their marble caves, *Repent, repent.*

St John the Baptist,
WILLIAM DRUMMOND, early 17th century

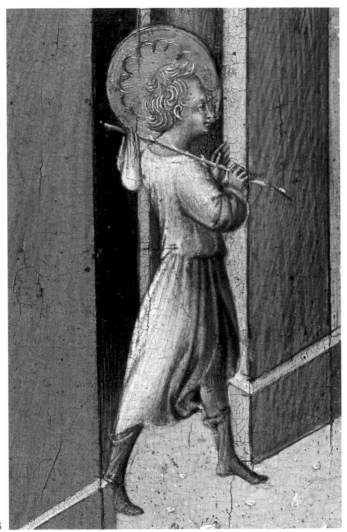

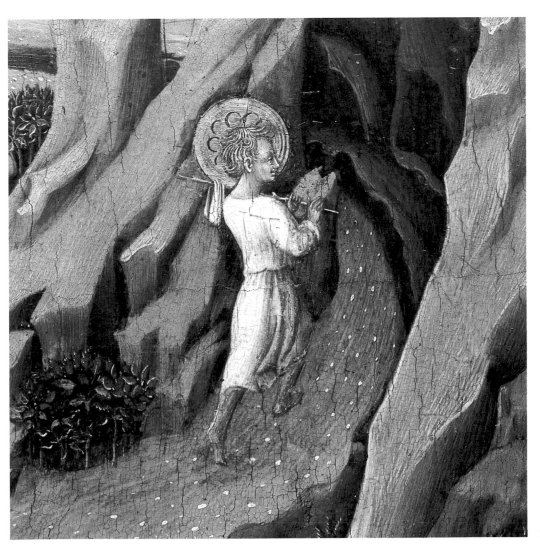

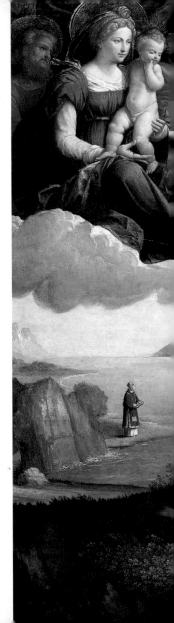

GAROFALO (about 1476–1559) Italian
*Saint Augustine with the Holy Family and Saint Catherine
of Alexandria ('The Vision of Saint Augustine')*
about 1520

Blessed are all thy Saints, O God and King, who have
travelled over the tempestuous sea of this mortal life, and
have made the harbour of peace and felicity. Watch over us
who are still in our dangerous voyage; and remember such as
lie exposed to the rough storms of trouble and temptations.
Frail is our vessel, and the ocean is wide; but as in thy mercy
thou hast set our course, so steer the vessel of our life
toward the everlasting shore of peace, and bring us at length
to the quiet haven of our heart's desire, where thou, O our
God, are blessed, and livest and reignest for ever and ever.

from *The Confessions of Saint Augustine*,
SAINT AUGUSTINE, about 400

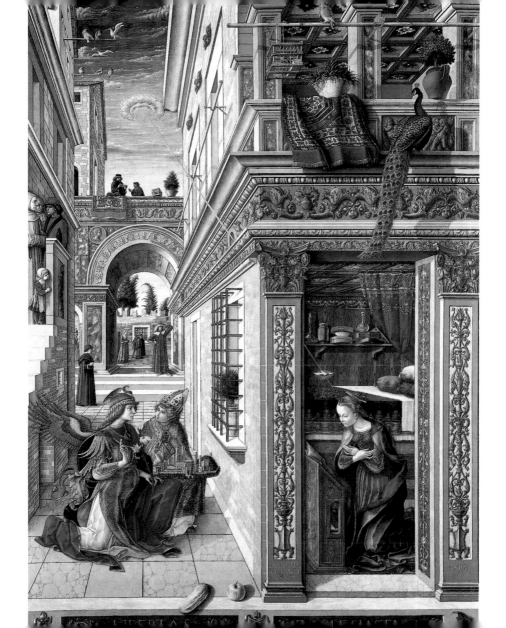

135

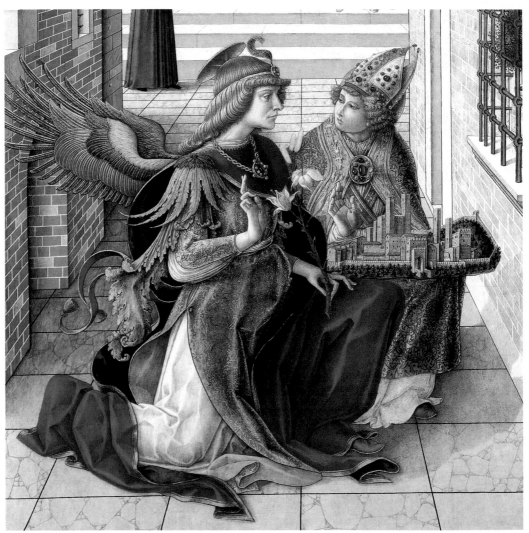

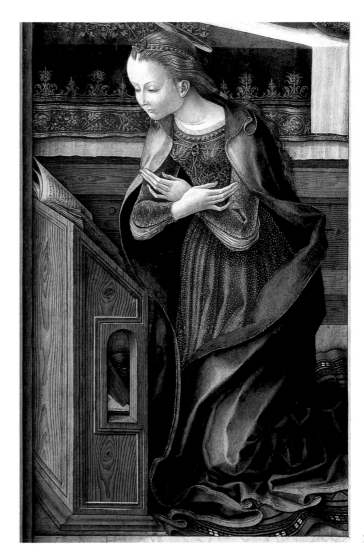

ARTISTS & PAINTINGS

ANGELICO, Fra
*Christ Glorified in the Court
of Heaven*
tempera on poplar,
32 x 73 cm, p.70

ANTONELLO da Messina
Attributed,
The Virgin and Child
oil on wood, painted surface
43.2 x 34.3 cm, p.77

BALDUNG Grien, Hans
The Trinity and Mystic Pietà
oil on oak,
112.3 x 89.1 cm, p.65

BAROCCI, Federico
*The Madonna and Child
with Saint Joseph and
the Infant Baptist
(La Madonna del Gatto)*
oil on canvas,
112.7 x 92.7 cm, p.54

BAYEU y Subias, Francisco
*Saint James being visited by
the Virgin with a Statue of the
Madonna of the Pillar*
oil on canvas,
53 x 84 cm, p.74

BOTTICELLI, Sandro
'Mystic Nativity'
oil on canvas,
108.6 x 74.9 cm, p.11

BOTTICINI, Francesco
The Assumption of the Virgin
tempera on wood,
228.6 x 377.2 cm, p.37

CARAVAGGIO, Michelangelo
Merisi da
The Supper at Emmaus
oil and egg (identified) on
canvas,
141 x 196.2 cm, p.44

CHAMPAIGNE, Philippe de
The Vision of Saint Joseph
oil on canvas,
208.9 x 155.6 cm, p.25

CORTONA, Pietro da
Saint Cecilia
oil (identified) on canvas,
143.5 x 108.9 cm, p.113

COSTA, Lorenzo
*The Adoration of the
Shepherds with Angels*
oil on wood,
52.4 x 37.5 cm, p.41

CRIVELLI, Carlo
*The Annunciation, with Saint
Emidius*
egg and oil (identified)
on canvas, transferred
from wood,
207 x 146.7 cm, p.135

DUCCIO
The Annunciation
egg (identified) on poplar,
painted surface
43 x 44 cm, p.17

ELSHEIMER, Adam
After,
*Tobias and the Archangel
Raphael returning with the
Fish*
oil on copper,
19.3 x 27.6 cm, p.29

GAROFALO
*Saint Augustine and the Holy
Family and Saint Catherine
of Alexandria ('The Vision of
Saint Augustine')*
oil on wood,
64.5 x 81.9 cm, p.129

GEERTGEN TOT SINT JANS
The Nativity, at Night
oil on oak,
34.3 x 25.1 cm, p.47

GIOVANNI, di Paolo
*Saint John the Baptist
retiring to the Desert*
tempera on poplar,
31.1 x 38.8 cm, p.124

GOSSAERT, Jan
The Adoration of the Kings
oil (identified) on wood,
177.2 x 161.3 cm, p.50

GUERCINO
*The Angel Appearing to
Hagar and Ishmael*
oil on canvas,
193 x 229 cm,
Collection of Sir Dennis
Mahon, on loan to the
National Gallery, London p.8

LEONARDO da Vinci,
Associate of,
An Angel in Red with a Lute
oil (identified) on poplar,
118.8 x 61 cm, p.21

LIPPI, Fra Filippo
Seven Saints
tempera on wood,
68 x 151.5 cm, p.108

MARGARITO of Arezzo
*The Virgin and Child
Enthroned, with Scenes
of the Nativity and the Lives
of the Saints*
tempera on wood,
including frame
92.5 x 183 cm, p.88

PISANELLO
The Vision of Saint Eustace
tempera on wood,
54.5 x 65.5 cm, p.118

POUSSIN, Nicolas
The Annunciation
oil on canvas,
105.8 x 103.9 cm, p.82

PROVOOST, Jan
Attributed,
*The Virgin and Child
in a Landscape*
oil on oak,
60.3 x 50.2 cm, p.90

RENI, Guido
*Christ embracing Saint John
the Baptist*
oil (identified) on canvas,
48.5 x 68.5 cm, p.61

The Coronation of the Virgin
oil on copper,
66.6 x 48.8 cm, p.101

UCCELLO, Paolo
Saint George and the Dragon
oil on canvas,
56.5 x 74 cm, p.104

VALDES LEAL, Juan de
*The Immaculate Conception
of the Virgin, with Two
Donors*
oil on canvas,
189.7 x 204.5 cm, p.97

THE WILTON DIPTYCH
*Richard II presented to the
Virgin and Child by his
Patron Saint John the
Baptist and Saints Edward
and Edmund*
egg (identified) on oak,
each wing
53 x 37 cm, p.33

Writers & Works

Acknowledgments

The editor and publishers gratefully acknowledge permission to reprint copyright material below. Every effort has been made to contact the original copyright holders of the material included. Any omissions will be rectified in future editions.

The Holy Man by Brendan Kennelly from 'Love of Ireland' published by Mercier Press by permission of the author and publisher.

The Good by Brendan Kennelly from 'Breathing Spaces' published by Bloodaxe Books by permission of the author and publisher.

Meeting with a Stranger by James Kirkup by kind permission of James Kirkup and Oxford University Press. The poem first appeared in the poet's collection 'The Submerged Village' (1951) and was reprinted in his 'Collected Shorter Poems' volume 1; 'Omens of Disaster' by Salzburg University Press.

Our Lady of Walsingham, The Quaker Graveyard of Nantucket by Robert Lowell from 'Selected Poems' by Robert Lowell published Faber & Faber Ltd. by permission of the publisher.

Our Lady of Walsingham, The Quaker Graveyard of Nantucket from 'Lord Weary's Castle', copyright 1946 and renewed 1974 by Robert Lowell, reprinted by permission of Harcourt Brace & Co.

The Annunciation by Edwin Muir from 'Collected Poems' by Edwin Muir published by Faber & Faber Ltd. by permission of the publisher.

The Annunciation by Edwin Muir from 'Collected Poems' by Edwin Muir. Copyright © 1980 by Willa Muir. Used by permission of Oxford University Press, Inc.

The Plain Facts by Ruth Pitter. Copyright © Mark Pitter by permission of Mark Pitter.

On the Marriage of a Virgin by Dylan Thomas from 'Collected Poems: 1934–1952 published by J.M. Dent & Sons Ltd by permission of David Higham Associates.

On the Marriage of a Virgin by Dylan Thomas from 'The Poems of Dylan Thomas'. Copyright © 1943 by New Directions Publishing Corp. Reprinted by permission of New Directions Publishing Corp.

excerpt from *War and Peace* by Leo Tolstoy translated by Constance Garnett by kind permission of A. P. Watt Ltd. on behalf of the Executors of the estate of Constance Garnett.

The Magi by William Butler Yeats from 'The Collected Poems of W. B. Yeats' by permission of A. P. Watt Ltd. on behalf of Michael Yeats.

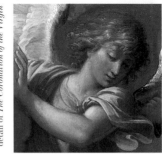

Title page: Garafolo, detail of *Saint Augustine and the Holy Family and Saint Catherine of Alexandria*, (*'The Vision of Saint Augustine'*) about 1520

Messengers of Grace title page: Guercino, *The Angel Appearing to Hagar and Ishmael*, 1652–53, Collection of Sir Dennis Mahon, on loan to the National Gallery, London

The Light of the World title page: Michelangelo Merisi da Caravaggio, *The Supper at Emmaus*, 1601

Queen of Heaven title page: Francisco Bayeu y Subias, *Saint James being visited by the Virgin with a Statue of the Madonna of the Pillar*, 1760

Saints title page: Paolo Uccello, *Saint George and the Dragon*, about 1460